NEW YORK
Lights Up

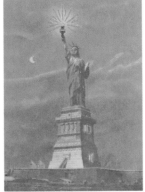

All of the works reproduced in this book are from the collection of The Metropolitan Museum of Art, unless otherwise noted.

First edition for the United States, its territories and dependencies, and Canada published in 2006 by The Metropolitan Museum of Art and Barron's Educational Series, Inc., 250 Wireless Boulevard, Hauppauge, New York 11788

Produced by the Department of Special Publications, The Metropolitan Museum of Art:
Robie Rogge, Publishing Manager; Jessica Schulte, Project Editor; Anna Raff, Designer; Mahin Kooros, Production Manager.

All photography by The Metropolitan Museum of Art Photograph Studio, unless otherwise noted.

International Standard Book No-10 (MMA): 1-58839-160-4

International Standard Book No.-13 (Barron's): 978-0-7641-5960-2
International Standard Book No.-10 (Barron's): 0-7641-5960-7

Library of Congress Catalog Card No. 2005933130

Visit the Museum's website: www.metmuseum.org
Visit the Barron's website: www.barronseduc.com

First Edition
Printed in Thailand

9 8 7 6 5 4 3 2 1

COVER: *Statue of Liberty and Manhattan Skyline* (detail). American, 1958. Commercial color process greeting card, 5¾ x 7⁷⁄₁₆ in. The Jefferson R. Burdick Collection, Gift of Jefferson R. Burdick, album 562, p.2r(2)

HALF-TITLE PAGE: *Statue of Liberty, New York.* Illustrated Post Card Company, publisher, American (New York), ca. 1905. Color lithographic postcard, 5½ x 3½ in. The Jefferson R. Burdick Collection, Gift of Jefferson R. Burdick, album 455, p.17r(5)

TITLE PAGE: *Metropolitan Museum of Art. New York City.* Probably J. Koehler, publisher, American (New York), early 20th century. Lithographic postcard, 5½ x 3½ in. The Jefferson R. Burdick Collection, Gift of Jefferson R. Burdick, album 455, p.16r(5)

Empire State Building, New York. Detroit Publishing Company, American, early 20th century. Color lithographic postcard, 5½ x 3½ in. The Jefferson R. Burdick Collection, Gift of Jefferson R. Burdick, album 417, p.12r(2)

Empire State Building, New York, N.Y. (detail). Detroit Publishing Company, American, early 20th century. Color lithographic postcard, 5½ x 3½ in. The Jefferson R. Burdick Collection, Gift of Jefferson R. Burdick, album 417, p.11r(5)

Chrysler Building at Night, New York City (detail). Frank E. Cooper, American, early 20th century. Curt Teich and Company, Incorporated, publisher, American (Chicago). Color lithographic postcard, 5½ x 3½ in. Private collection

Broadway at Night, New York. Detroit Publishing Company, American, ca. 1922. Color lithographic postcard, 3½ x 5½ in. The Jefferson R. Burdick Collection, Gift of Jefferson R. Burdick, album 417, p.9v(1)

St. Patrick's Cathedral, New York. Illustrated Post Card Company, publisher, American (New York), ca. 1905. Photomechanical process postcard, 5⁵⁄₁₆ x 3½ in. The Jefferson R. Burdick Collection, Gift of Jefferson R. Burdick, album 456, p.21r(3)

Rockefeller Center. Designed by Joseph W. Golinkin, American, 1896–1977. American Artists Group, publisher, mid-20th century. Commercial color process greeting card, 5¾ x 4⁷⁄₁₆ in. The Jefferson R. Burdick Collection, Gift of Jefferson R. Burdick, album 561, p.39r(1)

Metropolitan Building at Night, New York. Detroit Publishing Company, American, before 1912. Color lithographic postcard, 5½ x 3½ in. The Jefferson R. Burdick Collection, Gift of Jefferson R. Burdick, album 416, p.52v(2)

The Flatiron by Night, New York. I. Underhill, publisher, American (New York), 1905. Commercial color process postcard, 5½ x 3½ in. The Jefferson R. Burdick Collection, Gift of Jefferson R. Burdick, album 405, p.35r(4)

Woolworth Building at Night, New York. Detroit Publishing Company, American, early 20th century. Color lithographic postcard, 5½ x 3½ in. The Jefferson R. Burdick Collection, Gift of Jefferson R. Burdick, album 417, p.7v(6)

Statue of Liberty, New York. Illustrated Post Card Company, publisher, American (New York), ca. 1905. Color lithographic postcard, 5½ x 3½ in. The Jefferson R. Burdick Collection, Gift of Jefferson R. Burdick, album 455, p.17r(5)

Statue of Liberty, Bedloe's Island, New York Harbor. J. Koehler, publisher, American (New York), early 20th century. Commercial process postcard, 3½ x 5½ in. The Jefferson R. Burdick Collection, Gift of Jefferson R. Burdick, album 455, p.9r(4)

Opening of the Brooklyn Bridge, New York, May 24, 1883. A. Major, publisher, American, 1883. Color lithograph, 15⁵⁄₁₆ x 24⁵⁄₁₆ in. The Edward W. C. Arnold Collection of New York Prints, Maps and Pictures, Bequest of Edward W. C. Arnold, 1954 54.90.709

BACK COVER: *The Flatiron by Night, New York.* I. Underhill, publisher, American (New York), ca. 1905. Commercial color process postcard, 5½ x 3½ in. The Jefferson R. Burdick Collection, Gift of Jefferson R. Burdick, album 405, p.35r(4)

BACK COVER: *Broadway at Night, New York.* Detroit Publishing Company, American, ca. 1922. Color lithographic postcard, 3½ x 5½ in. The Jefferson R. Burdick Collection, Gift of Jefferson R. Burdick, album 417, p.9v(1)

BACK COVER: *Chrysler Building at Night, New York City.* Frank E. Cooper, American, early 20th century. Curt Teich and Company, Incorporated, publisher, American (Chicago). Color lithographic postcard, 5½ x 3½ in. Private collection

BACK COVER: *Empire State Building, New York. N.Y.* Detroit Publishing Company, American, early 20th century. Color lithographic postcard, 5½ x 3½ in. The Jefferson R. Burdick Collection, Gift of Jefferson R. Burdick, album 417, p.11r(5)

NEW YORK
Lights Up

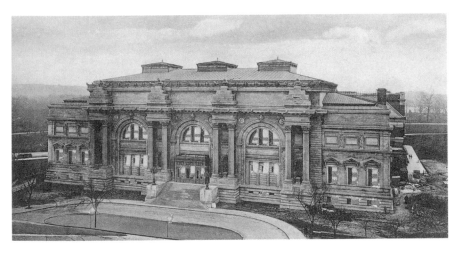

THE METROPOLITAN MUSEUM OF ART
NEW YORK

BARRON'S

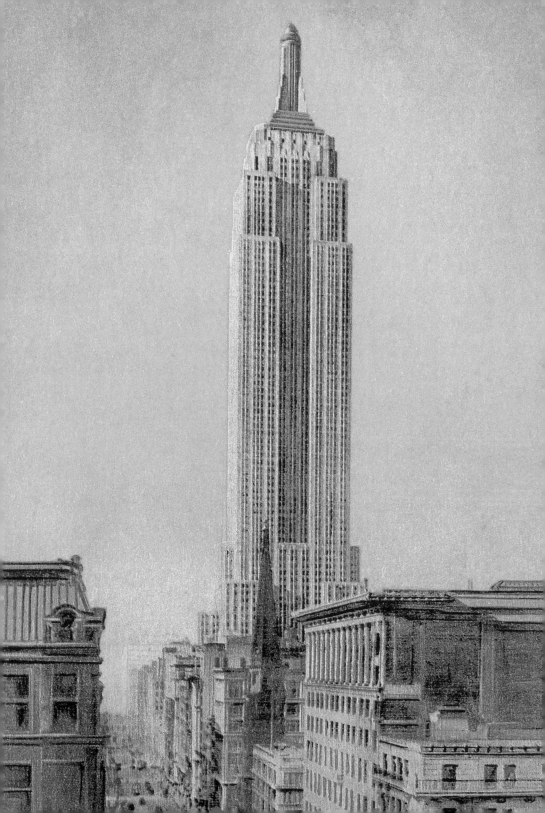

New York is always spectacular, but at night, it really lights up. . . .

The Empire State Building
rivals the brightest stars.

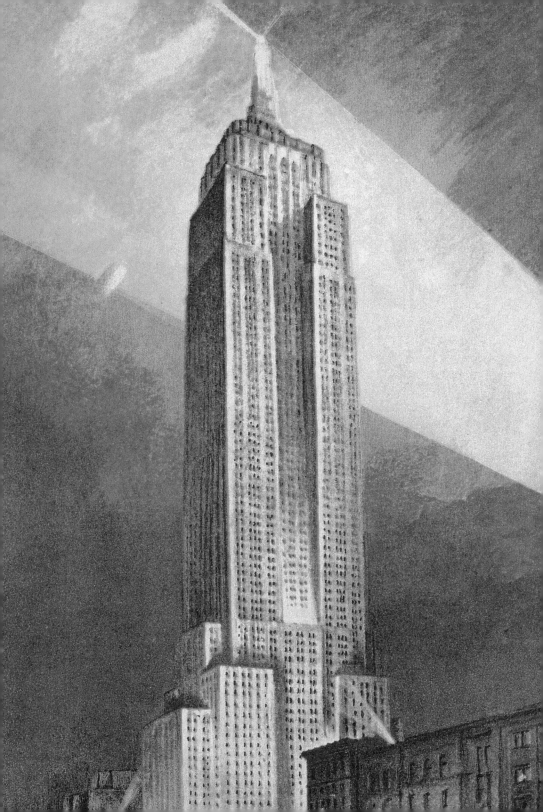

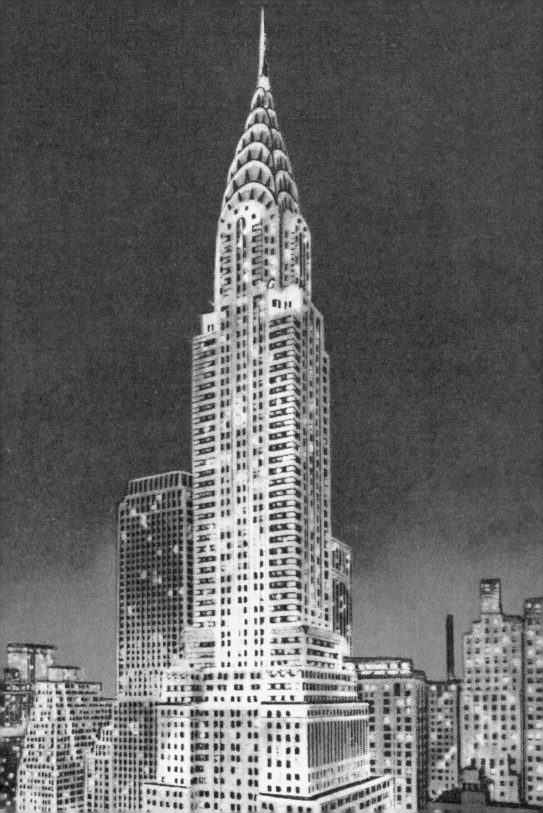

In Midtown, light reflects off the Chrysler Building, creating a magnificent Art Deco beacon.

In Times Square,
Broadway dazzles.

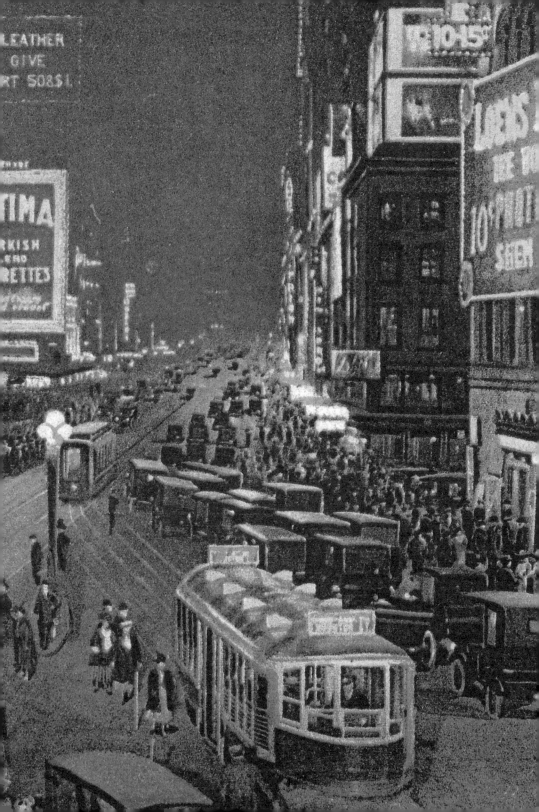

On Fifth Avenue, stained-glass windows shimmer in St. Patrick's Cathedral.

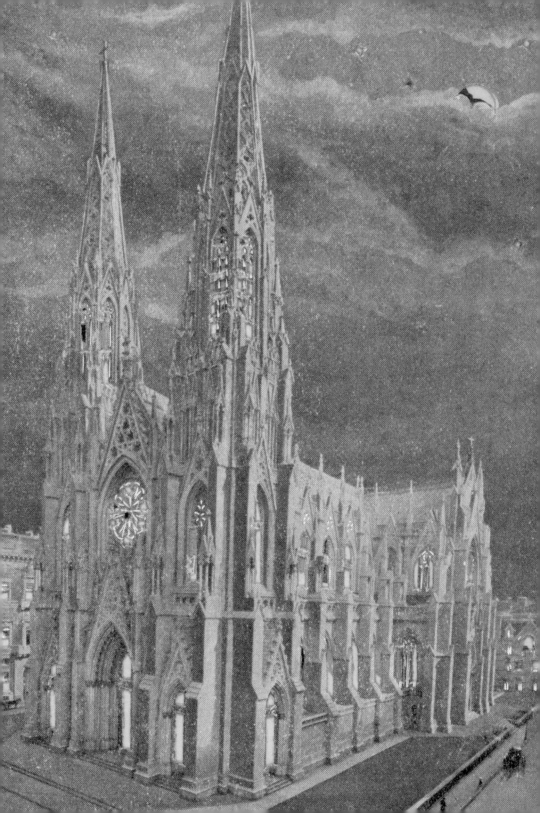

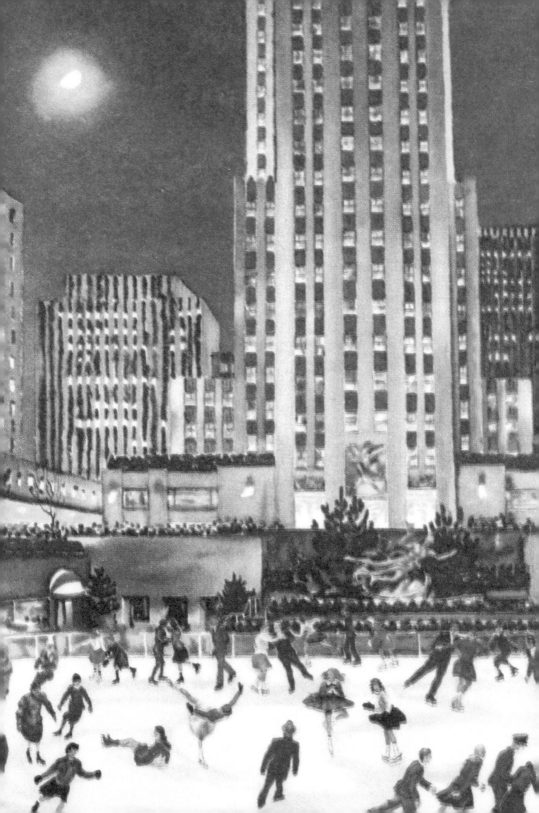

At Christmastime, the moon glows above ice skaters at Rockefeller Center.

In Madison Square, the clock of the Metropolitan Life Building illuminates the hour.

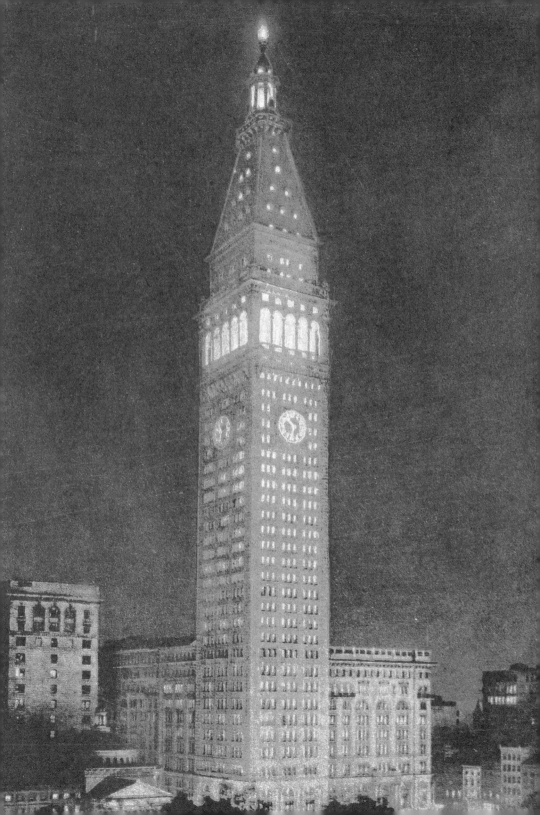

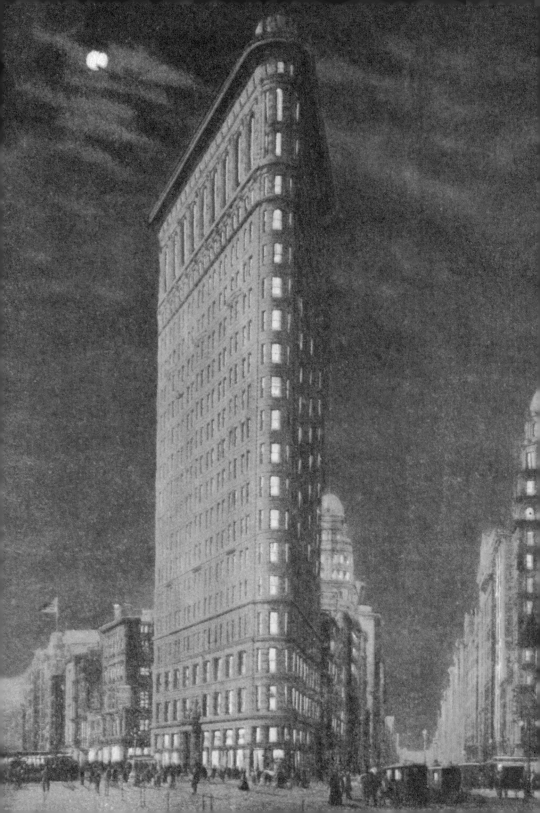

Across the square, the Flatiron Building's narrowest side flickers.

Towering over City Hall, the
Woolworth Building gleams.

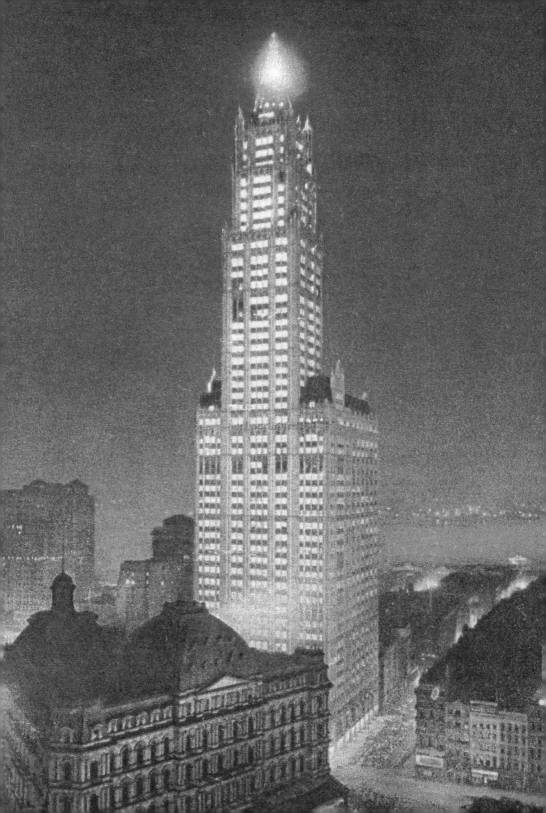

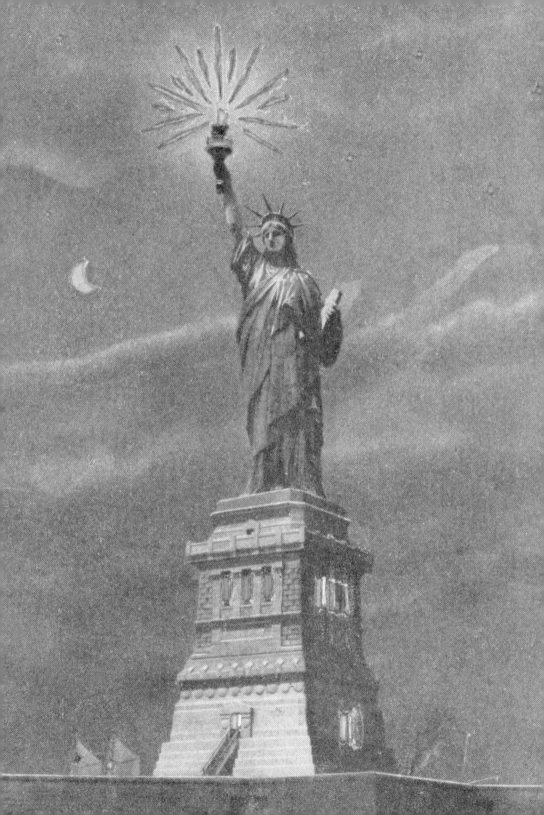

With her luminous torch,
the Statue of Liberty bids
the harbor goodnight.

Down below, boats shine a bright path through the water.